THE BRITISH MUSEUM
PRE-RAPHAELITES

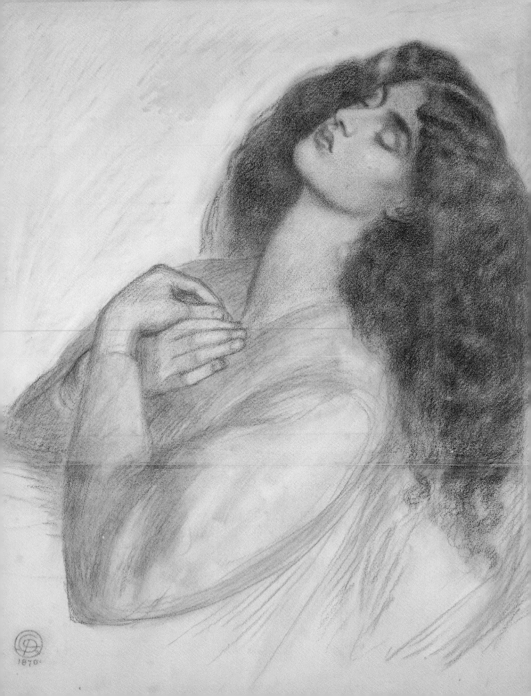

THE BRITISH MUSEUM
PRE-RAPHAELITES

Bethan Stevens

THE BRITISH MUSEUM PRESS

First published in 2008 by The British Museum Press
A division of The British Museum Company Ltd
38 Russell Square, London WC1B 3QQ
www.britishmuseum.co.uk

A catalogue record for this book is available from the British Library

ISBN 978-0-7141-5066-6

Quotations are reprinted by kind permission of the copyright holders (see p.95).

Frontispiece: Dante Gabriel Rossetti, *Study of Jane Morris,*
red, black and white chalk, 1870.

Photography by the British Museum Department of Photography and Imaging
Designed and typeset in Centaur by Peter Ward
Printed in China by C&C Offset Printing Co., Ltd

CONTENTS

PRE-RAPHAELITISM

SEVEN ARTISTS joined forces to form the Pre-Raphaelite Brotherhood (PRB) in 1848. They sought to make art that had as meaningful a relationship as possible to the real world, learning from earlier works, especially Italian art from before the time of Raphael (1483–1520). The artists were barely more than teenagers – Millais was still nineteen. The brotherhood dissolved a few years later, and its members developed divergent later careers. Nonetheless, for William Holman Hunt, John Everett Millais, Dante Gabriel and William Michael Rossetti, James Collinson, Frederic George Stephens and Thomas Woolner, and many of their associates, the name 'Pre-Raphaelite' continues to haunt their work and identities.

The PRB depicted both historical and modern-day subjects through a beguiling mixture of sharp realism and fantasy, creating a brash new style that they felt harked back to medieval tradition. Their ideas were rebellious and their work controversial. They had little respect for the mainstream Victorian art valued by the Royal Academy, describing the worst of it as 'sloshy'.

The Pre-Raphaelites did achieve critical success. But when the Victorian era ended, their reputation plummeted. It was felt that in the modern era, aesthetics of form must take precedence over pictorial narrative. Art historians have traced the dismissal of Pre-Raphaelitism by key modernist critics such as Clive Bell, for whom it was a 'puerile gospel of literary pretentiousness'. Bell blamed the Pre-Raphaelites for killing the great tradition of English art under Gainsborough and Constable. In a nutshell, he claimed: 'French revolutions in painting are fruitful, English barren – let the Pre-Raphaelite movement be my witness.'

In the second half of the twentieth century tastes changed once more, and since then Pre-Raphaelitism has enjoyed unprecedented success, emerging as *the* art of Victorian Britain, with a role to play in British visual culture equal to that of Impressionism in France. This book reproduces drawings through which the Pre-Raphaelites formulated their radical concepts of art and startling, perfectionist prints that they published in books and magazines, carrying their ideas to the widest possible number of Victorian viewers.

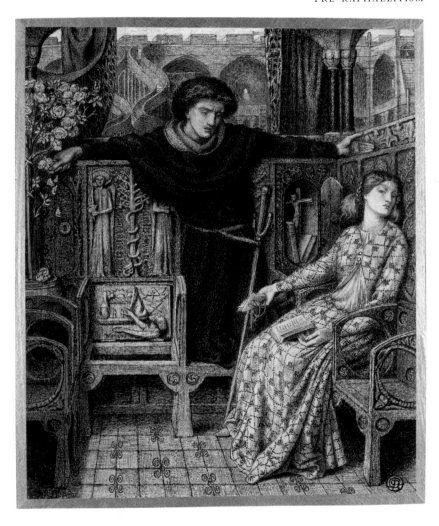

Dante Gabriel Rossetti, *Hamlet and Ophelia*, pen and black ink, *c.* 1858

T HE BROTHERHOOD was about collaboration. The artists attended drawing clubs together and shared work. They published their own journal, *The Germ*, illustrated by experimental etchings. This one is by Millais and has a delicacy characteristic of his early draughtsmanship. Most Pre-Raphaelite prints are wood-engravings, which were designed by Pre-Raphaelite artists and translated into print by specialist engravers. In contrast, in rare etchings such as this one, the lines were executed by the Pre-Raphaelites themselves.

The Germ was a short-lived project: this etching was intended for issue number 5, but publication ceased before it was produced. Millais is illustrating an eerie short story by Rossetti. A young Victorian painter discovers that he is the literal embodiment of a painter dead for four hundred years, Bucciuolo Angiolieri. The hero becomes dangerously obsessed with his predecessor, and their identities blur. The etching illustrates a moment in the story when Bucciuolo is painting his loved one, who dies just as the picture nears completion. Millais presents us with a striking blend of modernity and medievalism, appropriate for the story and characteristic of Pre-Raphaelitism. This is also one of a number of Pre-Raphaelite works in which female sexuality and death are disturbingly linked.

Rossetti had tried to illustrate his story himself but was unhappy with the result and destroyed his plate. The fact that Millais — whose work in later years grew antithetical to Rossetti's — took up the project in his friend's stead indicates the kind of intellectual sympathy the artists enjoyed in the years of the brotherhood.

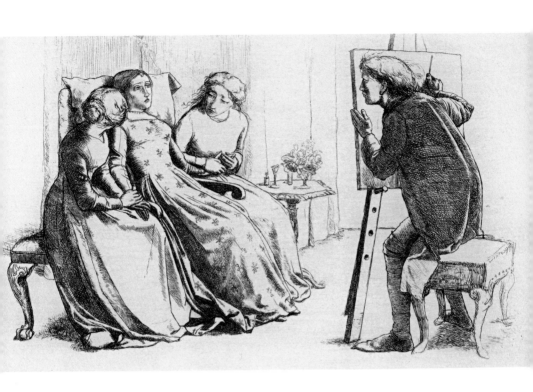

John Everett Millais, *St Agnes of Intercession*, etching, 1850

T HE PRE-RAPHAELITES did not write a manifesto. It was John Ruskin who in 1851 provided the public with a theory of the movement, defending it from harsh criticism. The Victorian press saw in Pre-Raphaelitism 'mere eccentricity' and an 'antiquated style'. The bold new tones the artists used to create hyper-realistic pictures were described as 'colour borrowed from the jars in a druggist's shop'.

Ruskin was a sympathetic critic, but he had his own agenda. For example, he distanced himself from aspects of Pre-Raphaelite work that appeared to go against his own theological beliefs. Many of the artists would later become Ruskin's friends, but at that point he did not know them personally. Nevertheless, he immediately claimed to understand their intentions, playing down their delight in medieval revivalism, and highlighting their 'truth to nature'.

> They intend to return to early days in this one point only – that . . . they will draw either what they see, or what they suppose might have been the actual facts of the scene they desire to represent, irrespective of any conventional rules of picture-making; and they have chosen their unfortunate though not inaccurate name because all artists did this before Raphael's time, and after Raphael's time did *not* this, but sought to paint fair pictures, rather than represent stern facts; . . . from Raphael's time to this day, historical art has been in acknowledged decadence.

With these words Ruskin rewrote the history of art in the Pre-Raphaelites' favour. Their daring hyper-realism seemed an answer to his own exhortation eight years earlier that artists 'go to nature in all singleness of heart . . . rejecting nothing, selecting nothing, and scorning nothing; . . . rejoicing always in the truth.'

Primarily a writer, Ruskin himself made astonishingly naturalistic drawings such as this study of a dead duck. He founded The Ruskin School of Drawing at the University of Oxford, and has had a huge impact on art education in this country.

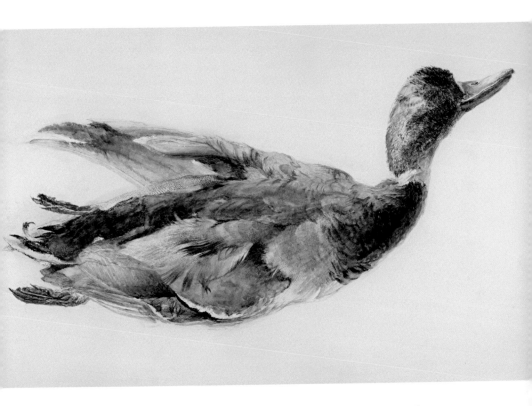

John Ruskin, *Study of a Dead Wild Duck*, watercolour, 1867

[GUINEVERE] Therefore, Sir Launcelot, I require thee and beseech thee heartily, for all the love that ever was betwixt us, that thou never see me more in the visage; and I command thee, on God's behalf, that thou forsake my company, and to thy kingdom thou turn again, and keep well thy realm from war and wrack; for as well as I have loved thee, mine heart will not serve me to see thee, for through thee and me is the flower of kings and knights destroyed.

[LAUNCELOT] I ensure you faithfully, I will ever take me to penance, and pray while my life lasteth, if I may find any hermit . . . that will receive me. Wherefore, madam, I pray you kiss me and never no more.

[GUINEVERE] Nay . . . that shall I never do.

Sir Thomas Malory, from *Morte d'Arthur*, Book XXI

ROSSETTI in particular idealized English medieval culture, continuing to do so after the Pre-Raphaelite Brotherhood had dissolved. This aspect of his work inspired two important followers, Edward Burne-Jones and William Morris. In this watercolour Rossetti draws an Arthurian scene for the first time: the subject is from Malory's *Morte d'Arthur*. King Arthur is dead, and the adulterous love affair of Guinevere and Launcelot is to blame. The queen has become a nun in penance, and she is now bidding Launcelot goodbye, refusing him a last kiss. The tomb, with its medievalized statue and painted decoration, alludes to the kinds of earlier artworks that inspired the Pre-Raphaelites.

Details such as the minimal realistic shadowing and the grass in the foreground gesture to a Pre-Raphaelite desire to faithfully represent nature. But Rossetti prioritized emotional detail over the naturalistic. Some oddities, like the way the characters and the tomb are squashed into the orchard, suggest he wanted intensity before verisimilitude. The long rectangular format of Rossetti's picture, and the dense, flat scene — almost all foreground — make the drawing itself claustrophobic and tomb-like.

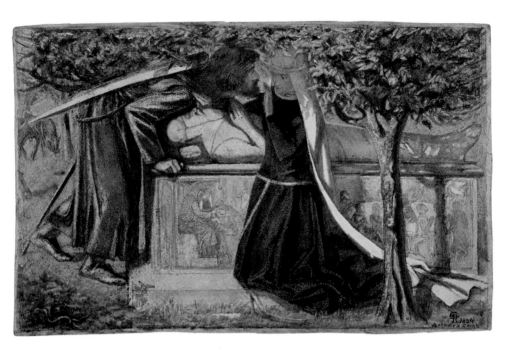

Dante Gabriel Rossetti, *Arthur's Tomb*, watercolour, 1855

The subject was a modern one, and indeed it has often seemed to me that all work, to be truly worthy, should be wrought out of the age itself, as well as out of the soul of its producer, which must needs be a soul of the age.

Dante Gabriel Rossetti, from 'St Agnes of Intercession'

If, as every poet, every painter, every sculptor will acknowledge, his best and most original ideas are derived from his own times . . . why transfer them to distant periods, and make them *not things of to-day?* . . . Why to draw a sword we do not wear to aid an oppressed damsel, and not a purse which we do wear to rescue an erring one?

Sculptor John Lucas Tupper in *The Germ*

THE PRE-RAPHAELITE BROTHERHOOD valued the example set by artists from the late Middle Ages, but they also cared passionately that their art should be relevant in the modern world. As well as being a great history painter, Millais made sensitive drawings and illustrations of middle-class Victorians, carefully depicting details such as contemporary fashion. He drew *Retribution* in 1854; it is one of several Pre-Raphaelite works that seek to scratch the surface of mainstream life, revealing the tragedy and corruption that could exist beneath.

The man in this drawing has just been exposed as leading a double life. His wife has arrived with their two children, discovering him with a beautiful young woman who, from the shock on her face, had no idea he was already married. The wedding bouquets on the table and the young woman's dress suggest the man was planning to commit bigamy. Formally, Millais constructed the drawing to lead the viewer's eye to his guilty expression. The gazes of the other figures are all directed towards him. Strong diagonal lines in his wife's cloak, his own extended leg, his daughter's body and her imploring arm, and the joined hands of the two betrayed women, all lead to the bowed head of this man who utterly failed in his social responsibilities. His own son, for whom he should be a role model, is leaning away from him in horror.

A further example of Pre-Raphaelite art that analyses contemporary society, particularly in terms of sexual corruption, is Rossetti's *Found* (p. 23), in which a young man from the countryside discovers his childhood sweetheart leading a miserable life in the city.

John Everett Millais, *Retribution*, pen and brown ink, 1854

Rossetti and Millais came from backgrounds that gave them a head start entering the art world. Rossetti was born into a cosmopolitan, artistic family, whereas Millais had a prosperous upbringing and had won prestigious drawing prizes since his childhood. In contrast, William Holman Hunt was a warehouse manager's son. He worked as an office clerk from the age of twelve, and fought hard to get his Royal Academy training and launch his career. His greatest artistic successes explored Christianity and ideas about conscience. Hunt rejected traditional religious painting, and developed a new style that was specifically English and evangelical.

After the Pre-Raphaelite Brotherhood had dissolved, Hunt claimed to be the only member who remained true to its principles. Thanks to Ruskin, the most important of these was understood to be Pre-Raphaelitism's adherence to naturalistic detail. Hunt came to the then radical conclusion that this required him to travel to the Middle East, in order to paint Biblical scenes in the actual landscapes in which they happened. Part of his revolutionary method involved using Middle Eastern along with European models, although Hunt's imperialist attitude to people he met on his travels was less progressive.

Hunt made this study of St Joseph while living in Jerusalem, as part of his preparation for the painting *The Triumph of the Innocents*. He later included the sketch as an illustration in his two-volume book *Pre-Raphaelitism and the Pre-Raphaelite Brotherhood* (1905). In this book, Hunt exploited the fact that he had gone to extreme lengths for his art – a journey to the Middle East was no small undertaking – to emphasize his dedication and work ethic.

William Holman Hunt, *Study for St Joseph*,
silverpoint and pencil, 1876

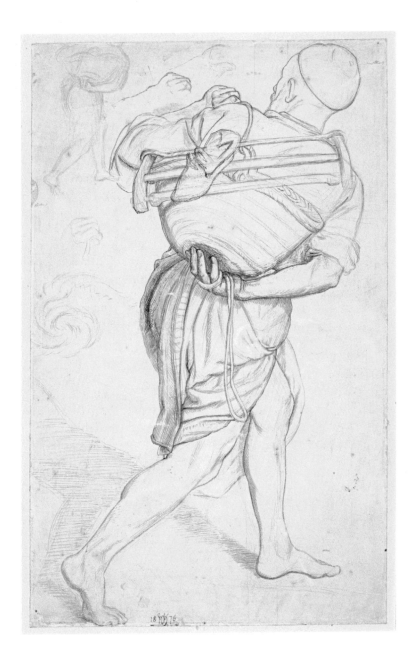

IN THE SPRING OF 1857, Millais's new painting *A Dream of the Past: Sir Isumbras at the Ford* failed to get the critical reception for which he had hoped. The painting showed a knight and two children riding a horse, and the animal in particular was ridiculed as resembling an ugly rocking horse, among other insults. Frederick Sandys made this caricature of the painting shortly after it appeared. The cartoon mimics the structure of the original; Millais's head has been substituted for the knight's, and the two children are Rossetti and Hunt. Poor Ruskin – who disliked Millais's painting and savaged it in his own review – is represented as the ass. The caricaturist, Sandys, was to become a friend of Rossetti and was a notable Pre-Raphaelite illustrator and painter.

Hunt later recalled watching a crowd outside a printshop window, trying to interpret this caricature. Not realizing it was about artists, the spectators were disputing which famous politicians it might represent. Hunt's anecdote is a reminder that Pre-Raphaelitism, like some developments in today's art world, was part of an elite artistic culture that was not always accessible or relevant to the public.

By 1857 the Pre-Raphaelite Brotherhood had not been active for four years. Nevertheless, this cartoon tells us that Rossetti, Hunt and Millais, its principal members, continued to be seen as a clique, although each was already pursuing quite distinct versions of Pre-Raphaelitism.

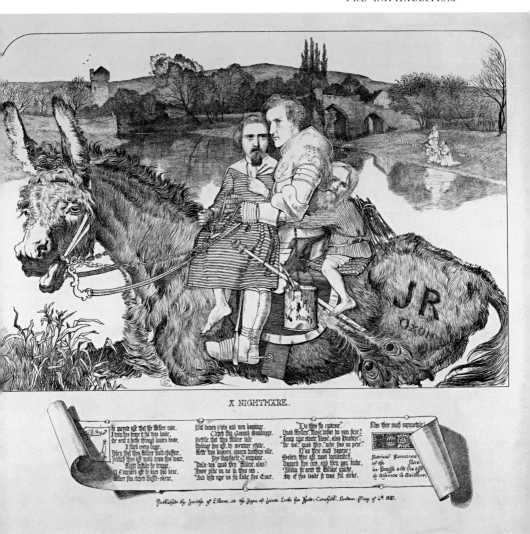

Frederick Sandys, *A Nightmare*, zincotype, 1857

WITH HIS STICK, a man is sketching a woman's portrait in the sand. There is an implied contrast between this ephemeral act of drawing – reminiscent of Rossetti's spontaneous portraits of his own lover, Elizabeth Siddal – and the watercolour itself, which is a product of labour, a finished drawing by a professional artist. A similarly wry contrast has been noted by art historians between the woman, whose ankles are revealed slightly as the wind catches her crinoline, and the nude bathers in the background. The woman was probably modelled by Siddal (see p. 29), and the drawing was made for the actress Ruth Herbert. The man is Richard Holmes, then working in the Manuscripts Department of the British Museum.

Never a landscapist, in this watercolour Rossetti is indifferent to Pre-Raphaelite ideals of truth to nature. The coastline and seascape were not painstakingly done on the spot. In fact, they were not even drawn from sketches by Rossetti himself, but were adapted from two drawings lent by a fellow artist, George Price Boyce.

Perhaps it is no wonder Rossetti eschewed what was a notoriously difficult working method. His great friend Ford Madox Brown often bemoaned the trials of making landscapes the Pre-Raphaelite way, i.e. painting everything outside rather than in the studio from an earlier sketch. Brown complained that it was impossible to paint any view before it was altered completely: 'one moment more a cloud passes and all the magic is gone.' Even an apparently prosaic subject caused great frustration: 'The field again . . . cold and wind . . . found the turnips too difficult to do anything with of a serious kind. I don't know if it would be possible to paint them well; they change from day to day.' For Rossetti, the discomforts of working outside were too great – he once tried it and ended up painting with an umbrella tied over his head.

Dante Gabriel Rossetti, *Writing on the Sand*,
watercolour, 1859

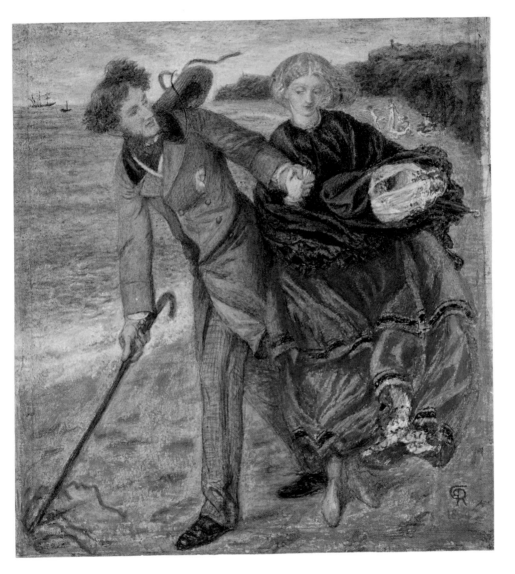

'There is a budding morrow in midnight:' –
So sang our Keats, our English nightingale.
And here, as lamps across the bridge turn pale
In London's smokeless resurrection-light,
Dark breaks to dawn. But o'er the deadly blight
 Of love deflowered and sorrow of none avail,
 Which makes this man gasp and this woman quail,
Can day from darkness ever again take flight?

Ah! gave not these two hearts their mutual pledge,
Under one mantle sheltered 'neath the hedge
 In gloaming courtship? And, O God! to-day
 He only knows he holds her; – but what part
 Can life now take? She cries in her locked heart, –
 'Leave me – I do not know you – go away!'

Dante Gabriel Rossetti, '"Found" (For a Picture)'

Dante Gabriel Rossetti, *Found*,
pen and ink and wash, 1853

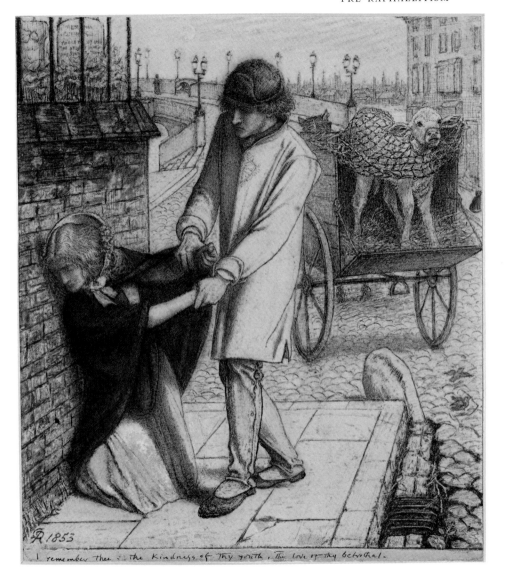

I remember thee : the kindness of thy youth, the love of thy betrothal.

By the early 1860s Millais had changed from the early days of the brother-hood, becoming a prolific artist and commercial success. There was even a market for small-scale watercolours after his paintings and engravings. This exquisite drawing of *The Black Brunswicker* is one of two later versions of a large painting he exhibited at the Royal Academy in 1860. The title alludes to a German troop who fought at the battle of Waterloo in 1815. 'They were nearly annihilated, but performed prodigies of valour', Millais wrote enthusiastically, characterizing this group of soldiers as a good story. *The Black Brunswicker* was planned as 'a perfect *pendant*' to a similar hit from years before, *The Huguenot*. Both engage with historical subjects; both show a handsome young couple aware that death may shortly come between them.

The sense of physical intimacy in this picture is heightened by the well-publicized story of the conditions of moral restraint in which it was produced. The two models posed separately, embracing wooden lay figures. They were a private soldier, from the Life Guards, and Kate Dickens, daughter of Charles Dickens. Choosing the right models had been essential to the Pre-Raphaelites. The artists questioned the convention of putting idealized faces in their pictures, preferring portraits of individuals. In fact, a decade earlier Charles Dickens had himself savagely criticized the ugliness of Millais's models in class terms, complaining that his Christ child belonged in a 'gutter' and his Virgin Mary in 'the lowest gin-shop in England'.

Millais worked fast and was unafraid to recycle successful ideas. The perfectionist Ford Madox Brown, true to Pre-Raphaelite ideals but forced to pawn his best clothes to feed his family, had ruefully commented on Millais's enviable speed in his diary in 1855: 'Millais, it seems, has finished his Fireman picture, although three weeks ago he had more than half uncovered, they say. How he does I can't tell.'

Another example of a fine watercolour copy by Millais is *A Lost Love* (p. 53), done not after a painting, but after a wood-engraving published in the magazine *Once a Week* in 1859.

John Everett Millais, *The Black Brunswicker*,
watercolour, 1863 or 1867

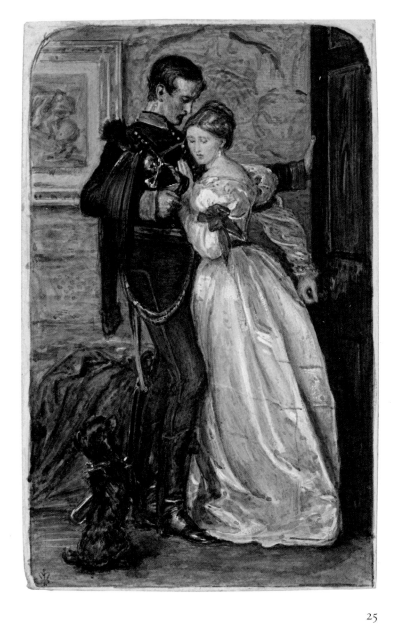

25

THE PRE-RAPHAELITE CIRCLE

ORD MADOX BROWN was an artist at the centre of Pre-Raphaelitism, though not part of the brotherhood. He had met Rossetti early in 1848 when the latter — frustrated by stagnant teaching at the Royal Academy — begged him to be his teacher. Brown's unique vision is now acclaimed, but he struggled to achieve the worldly success enjoyed by other Pre-Raphaelites. This was partly because Ruskin was unimpressed and neglected to draw public attention to his work.

This drawing is a study for Brown's *Take your Son, Sir*, a painting in which a mother, modelled by Brown's wife Emma, holds out her newborn son. The painting was begun in 1851, but Brown did not add the figure of the baby until, inspired by the birth of his second son Arthur in 1856, he made this drawing of his ten-week-old child. The baby is held awkwardly away, thrust towards the viewer. Brown was from a medical family, and this baby has been compared to a foetus in a womb. Part of the drapery under his bottom recalls an umbilical cord. Brown worked in a chaotic home environment and made a number of drawings of his infant children. Little Arthur also modelled for another painting, *Work*, in which he is the youngest of a group of siblings orphaned by cholera. Sadly, Arthur died before he was a year old. The Browns were often concerned about the family's health and this could extend to modelling activities, as when Brown drew his first newborn son: 'Tuesday I drew at the boy without his cap & they said I had given him a cold.'

The impression Brown's diaries give of his domestic life is of love mixed with anxiety and alienation. He was constantly worrying about finding money to support his family. When Emma Brown almost went into labour with their first son Brown describes catching a bus 'in distress of mind at not being able to afford a cab in such an emergency'. When Arthur died, they had to borrow money for the burial. Brown blamed his struggles on his career, once commenting in despair: 'What a miserable sad thing it is to be fit for painting *only*, and nothing, nothing, else! no outlet, no hope!'

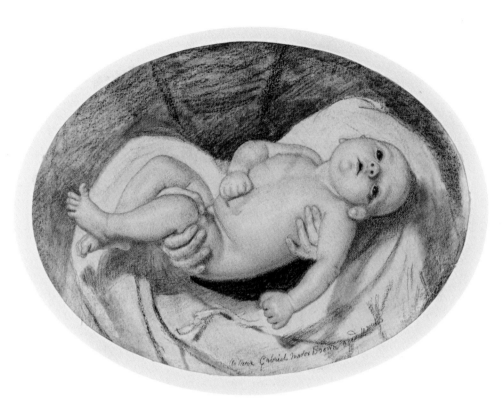

Ford Madox Brown, study for *Take your Son, Sir*,
graphite, black chalk and stump, 1856

There was one lady contributor, Miss E. E. Siddal, whose name was new to us. Her drawings display an admiring adoption of all the most startling peculiarities of Mr. Rossetti's style, but they have nevertheless qualities which entitle them to high praise.

Coventry Patmore, in *The Saturday Review*, 1857

Saw Miss Siddal, looking thinner and more deathlike and more beautiful and more ragged than ever; a real artist, a woman without parallel for many a long year. Gabriel, as usual, diffuse and inconsequent in his work. Drawing wonderful and lovely Guggums one after another, each one a fresh charm, each one stamped with immortality.

Ford Madox Brown, diary entry, 1854

'GUGGUMS' was Rossetti's nickname for Elizabeth Siddal, who was one of a number of Pre-Raphaelites who had to cope with the double identity of artist and model. Originally an employee in a dressmaking and millinery shop, she met the Pre-Raphaelites in 1850, becoming Rossetti's muse and then modelling for him exclusively. He made many portraits of her. The way she inspired him is immediately apparent in this drawing, in which so much personality is captured in a few sketched lines and brush strokes. Siddal's face appears in an array of stunning paintings, illustrations and drawings by Rossetti, including *The Maids of Elfen-Mere* (p. 47), *The Palace of Art* (p. 49) and *Hamlet and Ophelia* (p. 7). Siddal's own career as an artist was supported financially by Ruskin.

Recent critics have judged Siddal as an artist in her own right, but her creative achievements were often overshadowed by Rossetti, as the above quotation by Coventry Patmore suggests. In fact, her work is stark and arresting: see her enigmatic interpretation of the popular Pre-Raphaelite subject *The Lady of Shalott* (pp. 57–8). Rossetti and Siddal married in 1860 after a long, difficult relationship. She suffered from severe ill health, and after giving birth to a stillborn child in 1861, she died of an overdose in 1862.

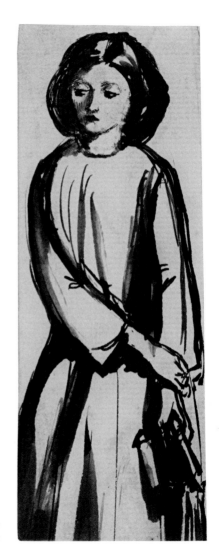

Dante Gabriel Rossetti, *Elizabeth Siddal*,
pen and ink and brown wash, *c.* 1854?

Edward Burne-Jones met William Morris when they were studying at Oxford, both planning careers in the Church. However, when they read Ruskin and started looking at Pre-Raphaelite art, these intentions unravelled. Realizing that art must take precedence for him, in 1856 Burne-Jones dropped out of university and moved to London. Rossetti became his art teacher.

In 1860 John Ruskin, who would become a life-long friend, characterized Burne-Jones's work in these terms: 'Jones is always doing things which need one to get into a state of Dantesque Visionariness before one can see them', adding moodily, 'I can't be troubled to get myself up, it tires me so.' Burne-Jones is thought of as a Pre-Raphaelite, but like Rossetti's later style, his work departs from the original tenets of the brotherhood. As well as being interested in the early Renaissance art that many Pre-Raphaelites emulated, Burne-Jones was fascinated by Classical art. He lived opposite the British Museum until 1864, and copied from the museum's collections. He became associated with the Aesthetic Movement, which saw the purpose of art as creating particular moods and feelings in the viewer, rather than being a vehicle for narrative.

In *St George fighting the Dragon*, Burne-Jones is still interested in dramatic narrative. It has been shown that decades later, Edward's wife Georgiana Burne-Jones looked again at his series of St George pictures from the 1860s. She asked him 'whether he had not purposely suppressed the dramatic element in his later work, and he said yes, that was so – for no one can get every quality into a picture, and there were others that he desired more than the dramatic.' Georgiana Burne-Jones was a writer and trained artist, whose talent was put at the service of her husband's art.

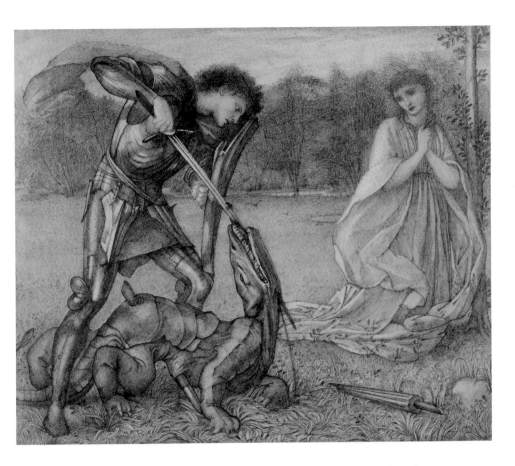

Edward Burne-Jones, *St George fighting the Dragon,*
pencil, *c.* 1865

ALONG WITH Burne-Jones, William Morris became a friend and follower of Rossetti in the 1850s. Morris was influenced by Rossetti's medievalism, which he reinvented as his own. Taking Pre-Raphaelitism in new directions, Morris abandoned oil painting and focused on decorative and book arts. He became an inspiration to the Arts and Crafts Movement. Unlike other members of the Pre-Raphaelite circle, Morris's revolutionary artistic convictions coincided with radical politics: in the 1880s he read Karl Marx and became a fervent socialist. Nevertheless, Morris kept his idealistic faith in the beauty – and radicalism – of medieval English society.

In 1859 Morris married Jane Burden, the daughter of a stable hand. She was to become a notable embroiderer and contribute to production and management in Morris's decorative arts company 'The Firm,' later 'Morris & Co.' Rossetti, Burne-Jones and Madox Brown were among the partners of 'The Firm' and all made designs.

Jane Morris later became Rossetti's model and muse, and the two had a passionate affair. Rossetti sent this cartoon to Jane while she and William were travelling to Bad Ems to take the waters. Jane Morris's signature features are instantly recognizable from famous paintings by Rossetti: deep eyes, full lips, mad hair. In this more intimate work she is shown taking a bath and sulkily drinking the second of seven tumblers of medicinal Ems water. Simultaneously, William is reading to her from his huge seven-volume poem, *The Earthly Paradise*. At the top of the drawing we see five more volumes yet to be read; at the bottom, five tumblers yet to be drunk. The joke is on William, as Rossetti explained to Jane Morris: 'The accompanying cartoon will prepare you for the worst, – whichever that may be, the 7 tumblers or the 7 volumes.'

An extract from William Morris's *The Earthly Paradise* with a design by Burne-Jones is on p. 41.

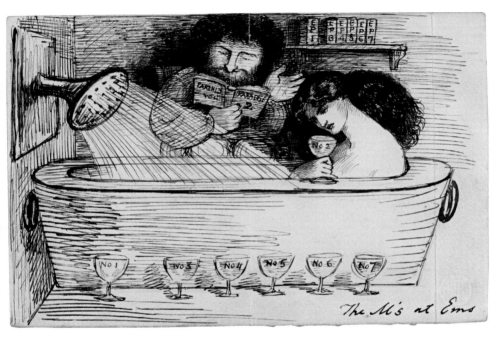

Dante Gabriel Rossetti, *The M's at Ems*,
pen and brown ink, 1869

'O Woodman, spare that block,
Oh gash not anyhow!
It took ten days by clock,
I'd fain protect it now.'
Chorus – Wild Laughter from Dalziel's Workshop

Dante Gabriel Rossetti, 'Address to the Dalziel Brothers'

THE DALZIEL BROTHERS – as they were known, although they included a sister – were responsible for engraving a high proportion of Pre-Raphaelite prints on to wood. In fact, they once humorously described themselves as another artistic 'Brotherhood'. The comic despair in the above verses by Rossetti shows how some artists felt at the mercy of the engravers who translated their designs. Nevertheless, the Dalziel family were a key institution of the Victorian art world, and shaped Pre-Raphaelite book illustration. This photograph is of George Dalziel, the senior member of the firm.

The Victorian Age saw revolutions in print-making. Wood-engraving – a more delicate and precise art than the old woodcuts – replaced copper and steel engraving as the preferred printmaking technique. Wood-engraving had many advantages: the blocks were tough, and illustrations could be printed in large editions without adverse effects on quality. The medium was also relatively cheap, since wood-engravings were printed on a standard press alongside the text (copper and steel plates had to be printed separately on an intaglio press, and later bound into a book). Thanks to wood-engraving, there was a burgeoning of illustration at this time, and a new aesthetic.

Alongside technical developments, the profession modernized itself. Whereas before, individual engravers had worked in small workshops, helped by apprentices, in the Victorian era the printmaking trade became dominated by larger firms such as those of the Dalziels and Joseph Swain. They themselves worked as engravers but also employed a number of anonymous jobbing engravers, and they developed systems for translating drawings into prints.

George Dalziel, photograph, *c.* 1880s

BURNE-JONES made thirty-eight watercolours for his Flower Book between 1882 and 1898. He said that he could only do them when in Rottingdean, a rural retreat – he called it 'a little village near hateful Brighton' – whose landscape and seascape inspired many of the pictures. His wife Georgiana Burne-Jones saw in these watercolours 'a fuller expression of himself than exists elsewhere in his work'.

The Flower Book illustrates not flowers themselves, but their names. This one is *Love in a Tangle*; other names that inspired him included *Black Archangel, Key of Spring, Witches' Tree* and *Grave of the Sea*. Burne-Jones said his Flower Book would show 'how fantastic is my view of science' and conceived of the project as 'a Botany book for babies'. The pictures were reproduced posthumously as a limited edition colour-printed book in 1905, though when he began the project Burne-Jones had commented that '"coloured plates" sounds dreadful'.

In seeking out floral names and legends Burne-Jones drew on the expertise of his friend Eleanor Leighton, whom he also consulted for his well-known Briar Rose paintings: she sent him a sprig of briar to draw from. He wrote to her about the Flower Book around 1882:

> . . . on summer and autumn mornings mercifully give me a thought in your garden and some illumination will come, I know . . . You see how I want to deal with them: it is not enough to illustrate them – that is such poor work: I want to add to them or wring their secret from them.

Edward Burne-Jones, *Love in a Tangle*,
watercolour, 1882–98

Most of Burne-Jones's Flower Book designs are of fantastic rural landscapes. This one shows a cityscape, apparently a city wall, and is the only Flower Book design that is unpopulated. The drawing is dominated by the crucifixion tree. The overall mood may relate to Burne-Jones's loathing for winter, in which men are 'unfit for the world'. The closed-off view and the lonely, barren architecture also bring to mind his antagonism towards the urbanization of his London neighbourhood, described by Georgiana Burne-Jones in her biography of her husband:

> Our London home had for some years past been suffering many changes. The District Railway had been brought near us and the speculative builder followed: the old elms in the roadway were cut down and several acres of garden ground belonging to neighbouring houses laid waste as a beginning, while the respectable old name of Fulham was taken from us, and 'West Kensington' given in exchange. It was long before Edward could bring himself to use this without protest. The narrow lane into which our garden opened became a street, and a row of houses instead of the walnut-tree soon shewed above our wall. This fact helped Edward to decide upon building a large room across the end of the garden, which would serve . . . as a screen from the houses.

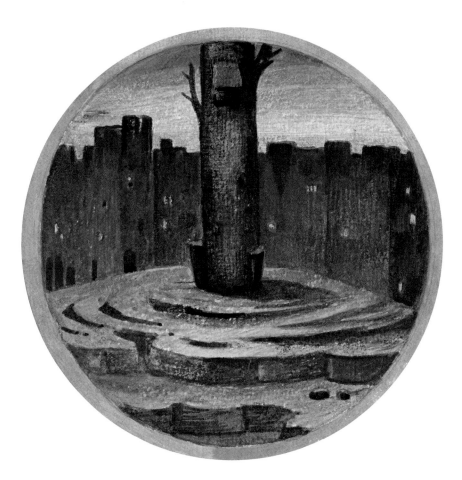

Edward Burne-Jones, *Arbor Tristis*,
watercolour, 1882–98

In gentle sleep he found the maiden laid.
One hand that held a book had fallen away
Across her body, and the other lay
Upon a marble fountain's plashing rim,
Among whose broken waves the fish showed dim,
But yet its wide-flung spray now woke her not,
Because the summer day at noon was hot,
And all sweet sounds and scents were lulling her.

So soon the rustle of his wings 'gan stir
Her looser folds of raiment, and the hair
Spread wide upon the grass and daisies fair,
As Love cast down his eyes with a half smile
Godlike and cruel; that faded in a while,
And long he stood above her hidden eyes
With red lips parted in a god's surprise.

Then very Love knelt down beside the maid
And on her breast a hand unfelt he laid,
And drew the gown from off her dainty feet,
And set his fair cheek to her shoulder sweet,
And kissed her lips that knew of no love yet,
And wondered if his heart would e'er forget
The perfect arm that o'er her body lay.

William Morris, from 'The Story of Cupid
and Psyche' in *The Earthly Paradise*

Edward Burne-Jones, *Cupid finding Psyche*,
watercolour and bodycolour, 1866

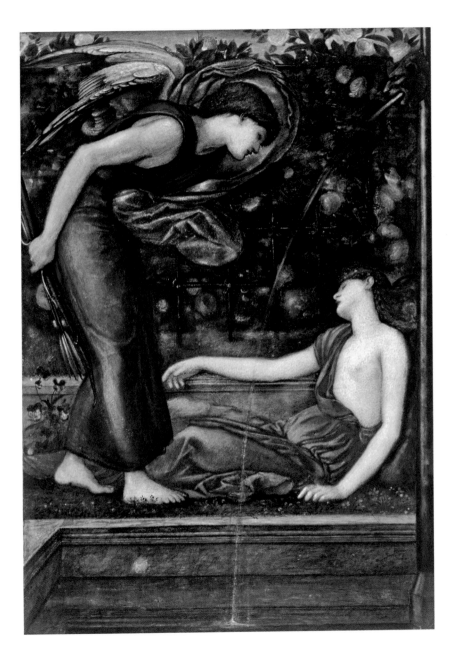

Some Pre-Raphaelites focused on producing pure landscape pictures to realize the ideal of 'truth to nature'. They included John Brett, who drew *Pansies and Fern Shoots*, and his sister Rosa Brett. Traditionally, the priority of landscape painters had been to produce harmonious pictures, their forms inspired by masters such as Claude or Turner, with colours chosen for visual effects rather than verisimilitude. Radically breaking with such conventions, Pre-Raphaelite landscapists structured their pictures according to the way they saw reality. Driven by an almost religious belief that nature could not be wrong, they aimed to reproduce colours as they were, even if they seemed to clash.

John Brett, an early admirer of Millais and Hunt, was patronized by Ruskin, who praised and purchased his work. However, Ruskin also had reservations, seeing one of Brett's landscapes as 'emotionless'. Another critic wrote rather condescendingly of 'John Brett, whose eyes are simple photographic lenses'. But if Brett's work is photographic, then it goes to show how uncanny filmic vision can be, at its most creative. For example, this luminous study of pansies is meticulously observed, but looks oddly alien. The pansies in the upper portion of the drawing are black – their bright yellow nectar guides glow like disembodied eyes, almost tricking us that this is a night-time scene. In contrast, the plants in the foreground seem anachronistically floodlit. By taking a small portion of vegetation out of its context in the landscape, Brett creates a strange, dramatic vision.

A design by Frederick Sandys with wonderfully detailed plant life, on p. 93, shows how Ruskinian ideals of naturalistic landscapes could be translated to the medium of wood-engraving.

John Brett, *Pansies and Fern-shoots*,
watercolour and bodycolour, 1862

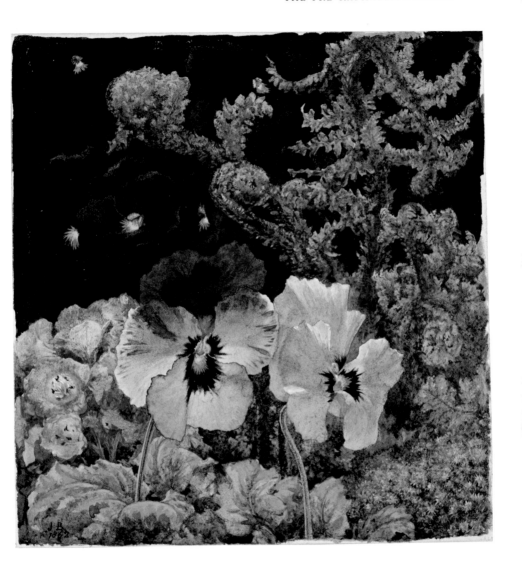

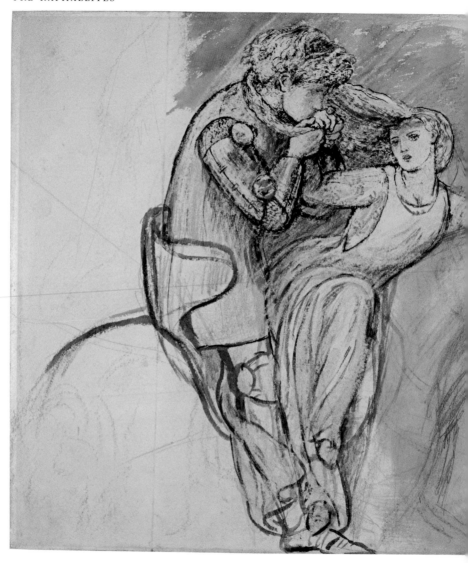

INTERPRETING POETRY

I set her on my pacing steed,
And nothing else saw all day long;
For sideways would she lean, and sing
A faery's song.

John Keats, from 'La Belle Dame Sans Merci'

T HIS IS THE FIFTH STANZA of Keats's ballad, inscribed on the drawing at the top right corner by Rossetti. He had made an earlier drawing for the same poem, when he belonged to a drawing club called the Cyclographic Society in 1848. The earlier image illustrates the fourth stanza, and the two figures are walking in woodland. In this later sketch Rossetti chooses the horseback scene to achieve a picture full of movement. Romantic poets and artists such as John Keats and William Blake were a source of inspiration to Rossetti, and he even directly incorporated Keats's words in his own poetry (see p. 22).

Dante Gabriel Rossetti, *La Belle Dame Sans Merci*,
pencil and wash, pen and ink, *c.* 1855

We are not forced to have illustrations to our books ... I think if we all understood the kind of labour it necessitates to produce a slight engraving, we should be less tolerant of this thoughtless multiplication of purposeless designs . . . [F]or every line so perpetuated in engraving, let us remember some human soul has forgone its freedom and invention and creative energy . . .

There is one . . . I cannot help noticing, for its marvellous beauty, a drawing . . . from the pencil of Rossetti, in Allingham's 'Day and Night Songs', just published; it is I think the most beautiful drawing for an illustration I have ever seen, the weird faces of the maids of Elfen-mere, the musical timed movement of their arms together as they sing, the face of the man, above all, are such as only a great artist could conceive.

Edward Burne-Jones in *The Oxford and Cambridge Magazine*, 1856

I F PRE-RAPHAELITE painting began in 1848, Pre-Raphaelite book illustration began in 1855, when Rossetti's *The Maids of Elfen-Mere* appeared in a new volume of poetry by William Allingham. The book featured two other Pre-Raphaelite artists: Millais and Arthur Hughes. But it was Rossetti's design that was the breakthrough. This was recognized by the young student Burne-Jones, who criticized the great mass of mediocre book illustrations then in circulation, singling out this wood-engraving as a turning point in British art.

Rossetti himself was blind to the success of *The Maids of Elfen-Mere*. He was incredibly anxious about it, fearing it could harm his reputation. Although he was then producing some of his best work, none of it was in the form of oil paintings suitable for public exhibition, which may explain his nervousness about the publication of this illustration. When Rossetti saw the proof he wrote: 'Dalziel has made such an incredible mull of it in the cutting that it cannot possibly appear', describing the engraver's rendering of his drawing as 'hard as a nail, and yet flabby and vapid'. The Dalziels defended themselves, claiming that Rossetti lacked understanding of the technical capabilities of wood-engraving.

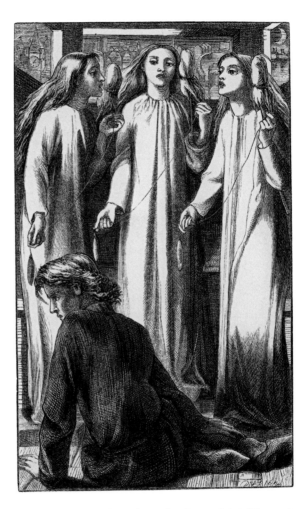

Dalziel Brothers after Dante Gabriel Rossetti,
The Maids of Elfen-Mere, wood-engraving, 1855

Or in a clear-wall'd city on the sea,
Near gilded organ-pipes, her hair
Wound with white roses, slept St Cecily;
An angel look'd at her.

Alfred Tennyson, from 'The Palace of Art'

I N 1857 EDWARD MOXON'S edition of Tennyson's *Poems* proved that Pre-Raphaelitism heralded a new age in print-making as well as in painting. Hunt, Rossetti and Millais featured alongside more conventional artists. Their small dense masterpieces shone out among the rest, and helped cement their reputation (see also pp. 52 and 55). Even twenty years later Rossetti sold three pictures to a new patron in Manchester who had liked this book. Moxon's publishing ambitions can be seen in the high calibre of the artists he commissioned, and the extraordinary fee paid for each drawing, reported to be as much as twenty-five pounds. Compare this to the three guineas Rossetti accepted two years before for *The Maids of Elfen-Mere* (p. 47).

The stanza reproduced here is the only connection between Tennyson's long poem and Rossetti's illustration. The link is tenuous, and Tennyson was said to be puzzled. The poet's St Cecilia is calmly sleeping, an angel watching. Rossetti's, on the other hand, is playing the organ in ecstasy, as an all-too-corporeal angel gives her a passionate kiss, perhaps a death kiss. Indeed, art historians have seen these illustrations as providing Rossetti with the chance to develop his own theory of book illustration. When contemplating them, he wrote to a friend explaining that the illustrator's aim should be to 'allegorize on one's own hook on the subject of the poem, without killing for oneself and everyone a distinct idea of the poet's'.

Nevertheless, Rossetti continued to be distressed by the translation of his designs into engravings, writing wryly to his friend William Bell Scott that he had designed 'five blocks for Tennyson, some of which are still cutting and maiming'. Nor did he like deadlines, working slowly on his illustrations and complaining about hassle from the overwrought publisher. After this project, Rossetti largely gave up drawing for wood-engravings, although he made exceptions for two of his sister's books in the 1860s (see pp. 68–71).

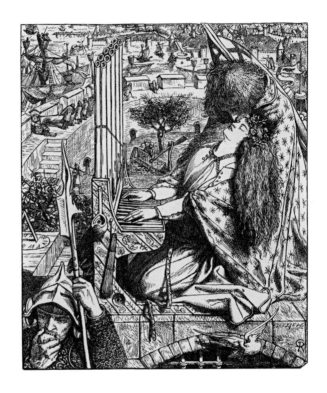

Dalziel Brothers after Dante Gabriel Rossetti,
The Palace of Art, wood-engraving, 1857

49

> She only said, 'My life is dreary,
> He cometh not', she said;
> She said, 'I am aweary, aweary,
> I would that I were dead!'
>
> *Alfred Tennyson*, from 'Mariana'

MILLAIS'S painting *Mariana* hung in the Royal Academy exhibition of 1851. Mariana was abandoned by her lover in Shakespeare's *Measure for Measure*, although Millais's source is not Shakespeare but rather Tennyson's poetic re-creation of the same character. Millais is faithful to the Tennyson, in which a 'thick-moted sunbeam' lights up the dismal house, and a shrieking mouse (see bottom right) contributes to the disturbing atmosphere.

Millais later made a completely different interpretation of 'Mariana', a wood-engraving (overleaf) for Moxon's edition of Tennyson's *Poems*. To fully exploit the black-and-white medium he chose the night-time part of the poem, in which the surroundings are grey and the moon low. The constraints of the small woodblock provided the ideal form to convey Mariana's entrapment. In his oil painting, Millais portrays her as stretching; in his wood-engraving, she is bent double in despair, situated in an architectural space that heightens the claustrophobia: an oppressive panelled room with such a low ceiling that she would be unable to sit up straight in her window seat, let alone stand.

In 1859 the artist reworked this visual motif for a magazine illustration and watercolour, *A Lost Love* (overleaf). The same poplars are outside the window, although the room is not claustrophobic and the woman is melancholy rather than desperate. The watercolour was made as a copy of a wood-engraving that appeared in the popular magazine *Once a Week*, illustrating verses signed 'R.A.B.':

> With a faded floweret in her hand,
> Poor little hand, so white!
> And dim blue eyes, from her casement high
> She looks upon the night.

John Everett Millais,
Mariana, oil on panel, 1850-51

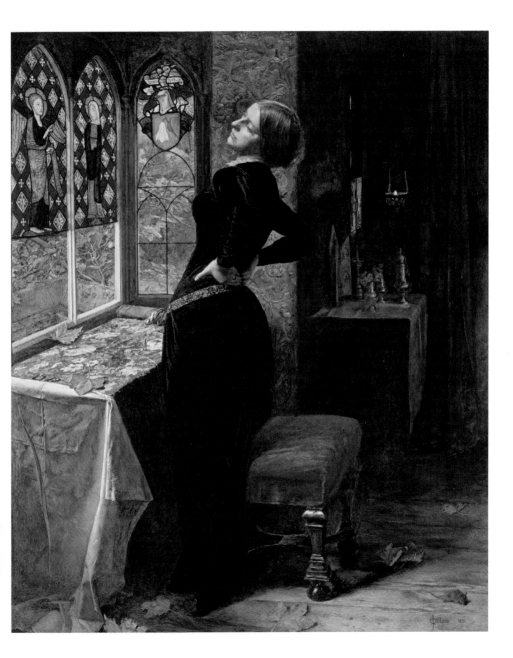

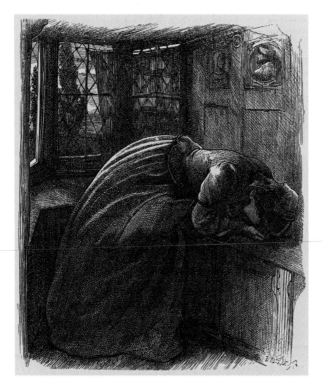

Dalziel Brothers after John Everett Millais,
Mariana, wood-engraving, 1857

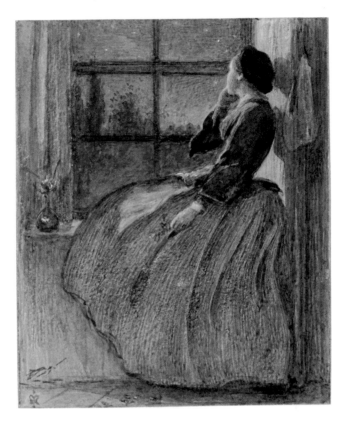

John Everett Millais, *A Lost Love*,
watercolour, 1859 or later

After some general talk [Tennyson] said, 'I must now ask why did you make the Lady of Shalott, in the illustration, with her hair wildly tossed about as if by a tornado?'

Rather perplexed, I replied that I had wished to convey the idea of the threatened fatality by reversing the ordinary peace of the room and of the lady herself; that while she recognised that the moment of the catastrophe had come, the spectator might also understand it.

'But I didn't say that her hair was blown about like that. Then there is another question I want to ask you. Why did you make the web wind round and round her like the threads of a cocoon?'

'Now,' I exclaimed, 'surely that may be justified, for you say —

Out flew the web and floated wide . . .'

But Tennyson broke in, 'But I did not say it floated round and round her.' My defence was, 'May I not urge that I had only half a page on which to convey the impression of weird fate, whereas you use about fifteen pages to give expression to the complete idea?' But Tennyson laid it down that 'an illustrator ought never to add anything to what he finds in the text.' . . .

'Ah, if so, I am afraid I was not a suitable designer for the book.' This I said playfully . . .

William Holman Hunt, from *Pre-Raphaelitism and the Pre-Raphaelite Brotherhood*

Hunt himself wrote down this conversation between Tennyson and himself decades later, and it must be altered by memory. Nonetheless we get an insight into the poet's ambivalent feelings towards the Pre-Raphaelites, whose paintings, illustrations and drawings were so often inspired by his poetry.

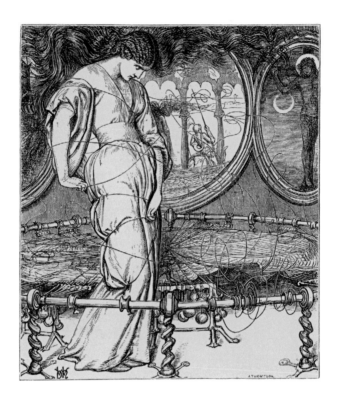

John Thompson after William Holman Hunt,
The Lady of Shalott, wood-engraving, 1857

There she weaves by night and day
A magic web with colours gay.
She has heard a whisper say,
A curse is on her if she stay
 To look down to Camelot.
She knows not what the curse may be,
And so she weaveth steadily,
And little other care hath she,
 The Lady of Shalott.

And moving thro' a mirror clear
That hangs before her all the year,
Shadows of the world appear.
There she sees the highway near
 Winding down to Camelot:
There the river eddy whirls,
And there the surly village-churls,
And the red cloaks of market girls,
 Pass onward from Shalott.

She left the web, she left the loom,
She made three paces through the room,
She saw the water-lily bloom,
She saw the helmet and the plume,
 She looked down to Camelot.
Out flew the web and floated wide;
The mirror cracked from side to side;
'The curse is come upon me,' cried
 The Lady of Shalott.

Alfred Tennyson, from 'The Lady of Shalott'

Elizabeth Siddal, *The Lady of Shalott*,
pen, black ink and sepia, 1853

THIS HUGE PAINTING, nearly two metres high, follows several other Pre-Raphaelite versions of Tennyson's poem 'The Lady of Shalott'. It illustrates the part of the poem in which the Lady of Shalott has submitted to temptation and looked at the real world, which she is supposed to view only through her magic mirror. The mirror cracks, and a horrible curse comes upon her. It is a scene that fascinated Hunt throughout his career. He first made a drawing of it in 1850, which he only stopped working on when, as he remembered, 'the paper was so worn that it would not bear a single new correction'. Then in 1857 he published a harsher wood-engraving of the same subject, in which the Lady has become strong and angry (see p. 55). For Hunt, as for Millais, the rigid form of the woodblock offered the perfect medium to portray a trapped woman: in none of Hunt's other versions is the Lady's head oppressively bent down by the edge of the picture as it is in the wood-engraving. Hunt liked his design so much that thirty years later he started adapting it for this tremendous painting, completed with the help of an assistant in 1905. The large scope of the canvas allowed him to convey the Lady's domestic imprisonment through a richly cluttered interior.

Elizabeth Siddal made a drawing of the same scene (see p. 57). Rossetti thought that Siddal ought to have been among the artists commissioned for Moxon's edition of Tennyson's *Poems*. Art historians have noted how, whereas in Hunt's version the Lady has lost control and is tied up for the viewer's pleasure, in Siddal's drawing she is poised and in control. It is argued that Siddal shows the Lady at her most powerful moment, when she breaks the rules and looks out of the window at the outside world. Hunt, in contrast, shows her being punished for that transgression.

William Holman Hunt, *The Lady of Shalott*, oil on canvas, 1886–1905

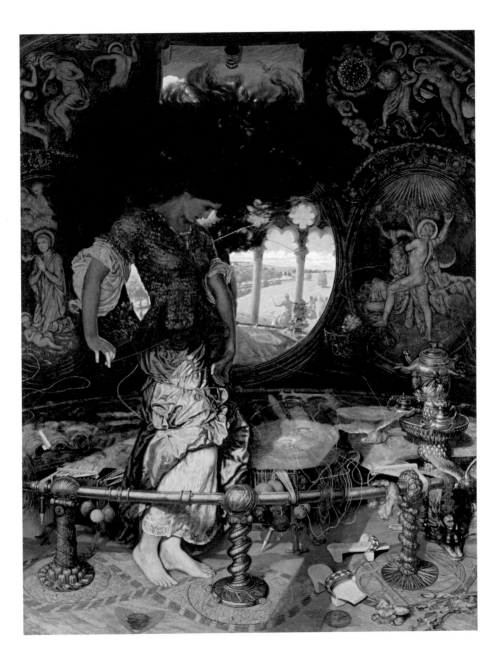

'THE LADY OF SHALOTT' was an overwhelmingly popular subject in Victorian art, used by Hunt, Siddal, Rossetti and later John William Waterhouse. Unsurprisingly, there was conflict over who would illustrate this poem when Moxon's edition of Tennyson's *Poems* was being planned. In his 1905 history of Pre-Raphaelitism, Hunt described how, early on in the Tennyson project, he asked Rossetti why he had failed to begin drawing anything. Hunt reports Rossetti's response:

> He avowed at once that he did not care to do any because all the best subjects had been taken by others. 'You, for instance, have appropriated The Lady of Shalott, which was the one I cared for most of all', he pleaded.
>
> 'You should have chosen at the beginning; I only had a list sent me of unengaged subjects,' I said. 'You know I made a drawing from this poem of the "Breaking of the Web" at least four years ago . . . My new drawing is now far advanced. I had determined also to illustrate the later incident in the poem, but that I will give up to you.'

Hunt's memory of dialogue from decades earlier is unreliable, but his account fits. This sketch represents Hunt's initial ideas for a second illustration to 'The Lady of Shalott', which he later re-worked into a different subject altogether. And indeed, in the Moxon Tennyson the scene in which the Lady's corpse drifts ashore in a boat was illustrated by Rossetti. Here, in Hunt's preliminary sketch, we see the artist at work thrashing out the germ of an idea. The scene he is planning is peaceful and open compared to his other design for the same poem (see p. 55).

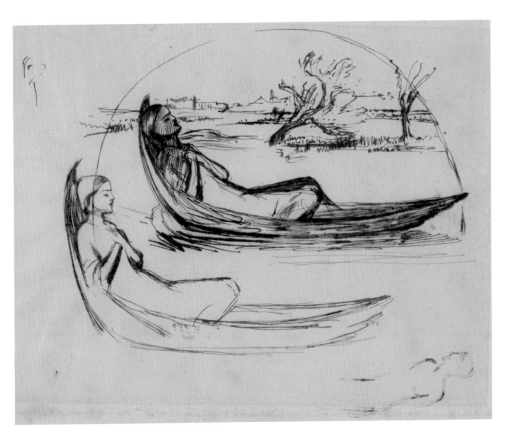

William Holman Hunt, *The Lady of Shalott*,
pen and brown ink, *c.* 1854–5

Out shopping, then to University hospital to ask John Marshall about a dead
boddy. He got the one that will just do . . . When I saw it first, what with the
dim light, the brown & parchment like appearance of it & the shaven head,
I took it for a wooden imulation of the thing. Often as I have seen horrors
I really did not remember how hideous the shell of a poor creature may remain
when the substance contained is fled. Yet we both . . . declared it to be lovely
& a splendid corps.

<div style="text-align: right">Ford Madox Brown, diary entry, 1856</div>

S PENDING DAYS in a mortuary was extensive research indeed: especially
when we consider the reality that Brown was designing an illustration, and
this could never command anything near the price of a painting — whatever
its artistic merit. With such working methods, Pre-Raphaelitism was barely
financially viable. Brown, as a perfectionist, suffered particularly.

Brown designed few wood engravings, and this is a proof impression
of one of his finest. He borrowed the structure and gothic mood from the
frontispiece to the first illustrated edition of *Frankenstein*, published in 1831 after
a design by Theodor von Holst, a Romantic artist admired by Rossetti. Brown's
design was commissioned for an anthology of nineteenth-century poetry, and
it illustrates Byron's 'The Prisoner of Chillon':

> He died — and they unlock'd his chain,
> And scoop'd for him a shallow grave
> Even from the cold earth of our cave.
> I begg'd them, as a boon, to lay
> His corse in dust whereon the day
> Might shine — it was a foolish thought, . . .
> They coldly laugh'd

Dalziel Brothers after Ford Madox Brown,
The Prisoner of Chillon, wood-engraving, proof, 1857

'The engines, Ho—back for your lives!' —
The swarthy helmets gleam:
Flash fast, broad wheel,
Hold, wood and steel,
Whilst the shout rings up, and the wild bells peal,
And the flying hoofs strike flame.
Stand from the causeway, horse and man,
Back while there's time for aid, —
Back gilded coach—back, lordly steed —
A thousand hearts hang on their speed,
And life and death and daring deed —

Room for the Fire Brigade!

H. Cholmondeley Pennell, from 'Fire'

IN 1855 MILLAIS had exhibited *The Rescue*, a painting in which a fireman inside a burning house is rescuing a woman and children, and city roofs are silhouetted through a window. Here, Millais offers us a glimpse of the street outside. Men looking and urgently pointing, the whip and straining horse, the strong horizontal lines, all create excitement and a drive towards the right. This is intensified by facial expressions: the determination of the man at the bottom left, sparsely delineated, and the wide-eyed central fireman, his mouth fallen open. Other firemen, such as the driver and those riding at the back, focus on smaller matters. This print was engraved in the workshop of Joseph Swain, the main competitor of the Dalziels (see p. 67 for another wood-engraving executed by Swain).

Joseph Swain after John Everett Millais,
Fire, wood-engraving, proof, 1869

As well as featuring in books, Pre-Raphaelite art appeared in popular Victorian magazines. These offered their readers a vast wealth of print, and alongside mediocre work could be found the best art and literature. Christina Rossetti's poem 'Amor Mundi' appeared with this wood-engraving designed by Frederick Sandys.

'Oh, where are you going with your love-locks flowing
On the west wind blowing along this valley track?'
'The downhill path is easy, come with me an' it please ye,
We shall escape the uphill by never turning back.'

So they two went together in glowing August weather,
The honey-breathing heather lay to their left and right;
And dear she was to doat on, her swift feet seemed to float on
The air like soft twin pigeons too sportive to alight.

'Oh, what is that in heaven where grey cloud-flakes are seven,
Where blackest clouds hang riven just at the rainy skirt?'
'Oh, that's a meteor sent us, a message dumb, portentous, –
An undecipher'd solemn signal of help or hurt.'

'Oh, what is that glides quickly where velvet flowers grow thickly,
Their scent comes rich and sickly?' – 'A scaled and hooded worm.'
'Oh, what's that in the hollow, so pale I quake to follow?'
'Oh, that's a thin dead body which waits th' eternal term.'

'Turn again, O my sweetest, – turn again, false and fleetest:
This way whereof thou weetest I fear is hell's own track.'
'Nay, too steep for hill-mounting, – nay, too late for cost-counting:
This downhill path is easy, but there's no turning back.'

Christina Rossetti, 'Amor Mundi'

Joseph Swain after Frederick Sandys,
Amor Mundi, wood-engraving, 1865

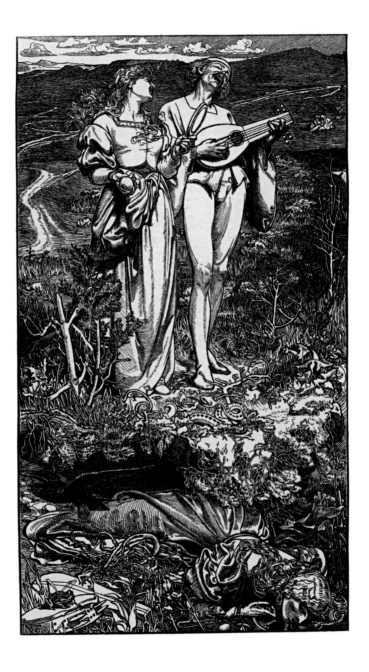

AFTER HIS BAD EXPERIENCES in the 1850s, Rossetti was reluctant to design illustrations. He was concerned about his name being attached to prints, when the work was in fact executed by wood-engravers. He had written to his mother describing one illustration 'which used to be by me till it became the exclusive work of Dalziel, who cut it'. Rossetti's dilemma is understandable. The rise of wood-engraving in the nineteenth century had brought about a change in attitude towards the authorship of reproductive prints. Partly due to the fact that designers now drew directly on to the woodblock whereas in the past the printmakers had taken a drawing or painting and translated it on to a copperplate themselves, nineteenth-century wood-engravings are even today described as being 'by' the designer who drew on the block. The lines were cut by wood-engravers, but these people's crucial work was increasingly perceived as mechanical.

When Rossetti agreed to illustrate his sister Christina Rossetti's *Goblin Market* (1862), he collaborated with the wood-engraver William James Linton, who was also a poet. The results show how effectively they worked together. The flexibility of texture is striking: the lace, the printed fabric and the girls' hair and, on the next page, the animal tail, woven basket and vegetation. This style of engraving differs noticeably from the networks of fine lines characteristic of Dalziel prints (see for instance p. 47).

As well as illustrating *Goblin Market*, Rossetti designed the layout of the title-page and an elegant cloth and gilt binding. Unlike in previous projects, he thus had a large degree of control over the book as an art object.

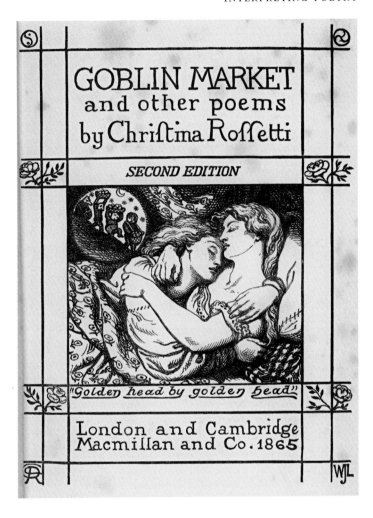

William James Linton after Dante Gabriel Rossetti,
Goblin Market, title-page, wood-engraving, 1862
(second edition, 1865)

'Come buy, come buy,' was still their cry.
Laura stared but did not stir,
Longed but had no money:
The whisk-tailed merchant bade her taste
In tones as smooth as honey,
The cat-faced purr'd,
The rat-paced spoke a word
Of welcome, and the snail-paced even was heard;
One parrot-voiced and jolly
Cried 'Pretty Goblin' still for 'Pretty Polly;' —
One whistled like a bird.

But sweet-tooth Laura spoke in haste:
'Good folk, I have no coin;
To take were to purloin . . .'
'You have much gold upon your head,'
They answered all together:
'Buy from us with a golden curl.'
She clipped a precious golden lock,
She dropped a tear more rare than pearl,
Then sucked their fruit globes fair or red:
Sweeter than honey from the rock,
Stronger than man-rejoicing wine,
Clearer than water flowed that juice;
She never tasted such before,
How should it cloy with length of use?
She sucked and sucked and sucked the more
Fruits which that unknown orchard bore;
She sucked until her lips were sore;
Then flung the emptied rinds away

Christina Rossetti, from 'Goblin Market'

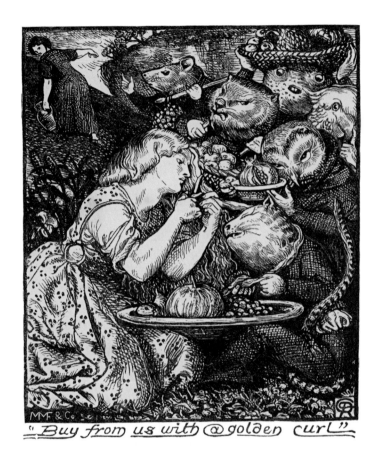

"Buy from us with @ golden curl"

William James Linton after Dante Gabriel Rossetti,
Goblin Market, frontispiece, wood-engraving, 1862
(second edition, 1865)

But with a penne coude she nat wryte;
But lettres can she weven to and fro,
So that, by that the yeer was al a-go,
She had y-woven in a stamin large
How she was broght from Athenes in a barge,
And in a cave how that she was brought;
And al the thyng that Tereus hath wrought

Geoffrey Chaucer, from 'The Legend of Good Women'

THIS IS A PROOF of one of the wood-engravings from the Kelmscott Chaucer; in the book it is printed with ornate margins and decorated text. The woman is Philomene who, after being raped by her brother-in-law Tereus, had her tongue cut out and was imprisoned. She manages to tell her story by weaving it.

William Morris set up the Kelmscott Press in 1891. The edition of Chaucer was its crowning success, published in 1896 with illustrations designed by Burne-Jones. Morris had long been troubled by the aesthetics of contemporary book production (see p. 94 for an illustration to one of his earlier, unfinished books from the 1860s). In the Kelmscott Press, Morris's answer to ill-thought-out book design and ugly typefaces was to abandon many modern technological advances and revive techniques from when printing was first invented in the fifteenth century, albeit with a radical new look.

Weaving was an important symbol in Pre-Raphaelite art (see pp. 55–9); in the Arts and Crafts movement it became an esteemed art in its own right. Weaving tapestries on a hand-loom had been one of Morris's passionate projects while running his furnishing and decorative arts company, Morris & Co.

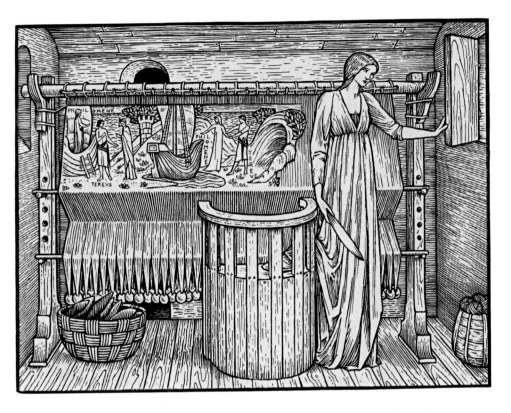

William Harcourt Hooper after Edward Burne-Jones,
The Legend of Good Women, wood-engraving, proof, 1896

INTERPRETING CHRISTIANITY

THE SUBJECT of this drawing is the Flood, in particular those who were *not* to be saved in Noah's ark (Matthew, ch. 24, v. 37–9). The scene is a marriage feast. The figure at the window watches the flood waters rise, and one or two of those present look out in shock or concern, while others remain oblivious, engrossed in their lives. Millais described the unfinished project in a letter:

> I shall endeavour in the picture I have in contemplation—'For as in the Days that were Before the Flood,' etc., etc.—to affect those who may look on it with the awful uncertainty of life and the necessity of always being prepared for death . . . One great encouragement to me is . . . its having this one advantage over a sermon, that it will be all at once put before the spectator without that trouble of realisation often lost in the effort of reading or listening.
>
> Millais, letter to Martha Combe, 1851

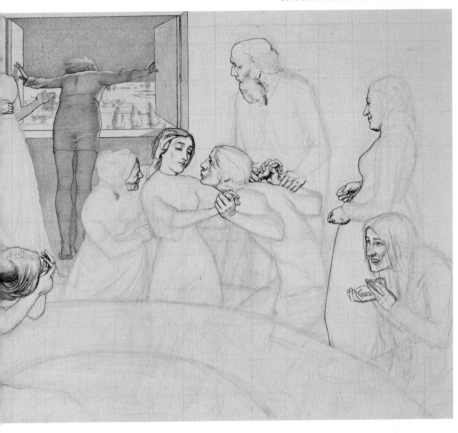

John Everett Millais, *The Eve of the Deluge*,
pencil, pen and ink and grey wash, *c.* 1850

Victorian Britain saw the creation of several masterpieces of illustration with a specifically Christian theme. Many appeared in magazines that combined catchy literature with vivid pictures. Such publications often had religious objectives. Millais's most ambitious wood-engraved project was *Parables of Our Lord*, commissioned and engraved by the Dalziel brothers. Twelve of the twenty wood-engravings first appeared in the journal *Good Words* in 1863. Some months later the series was published in book form by Routledge.

In their preface to *Parables of Our Lord*, and later published writings, the Dalziel brothers take pains to advertise the attention bestowed on this project, piously linking this to the religious subject matter. They cite the six years taken to complete the project as evidence of care, along with Millais's promise to make the *Parables* a 'labour of love' and their own determination to second 'his efforts with all earnestness, desiring . . . to make the Pictures specimens of the art of wood engraving'. Although the Dalziels presumably made such claims for marketing purposes, they do seem to be true. Millais by this time was supporting a family, and often executed designs swiftly for money. The *Parables*, however, were laboriously worked and re-worked. Millais wrote: 'I can do ordinary illustrations as quickly as most men, but these designs can scarcely be regarded in the same light.'

Millais had largely left Pre-Raphaelite realism behind, but something of it survives in this illustration in the startling depiction of the fur coat. The parable is 'The Importunate Friend': 'And I say unto you, Ask, and it shall be given you; seek, and ye shall find; knock, and it shall be opened unto you' (Luke, ch. 11, v. 5–13). Overleaf are illustrations to 'The Parable of the Ten Virgins' (Matthew, ch. 25, v. 1–13). Millais's wise virgins appear effortlessly in control of themselves, and their hairstyles, posture and facial expressions all in accord with contemporary ideals of femininity. The foolish virgins are portrayed more intimately – and less chastely. See especially the contrast between the graceful upright figure in 'The Wise and Foolish Virgins' and the desperate kneeling ones in 'The Foolish Virgins'.

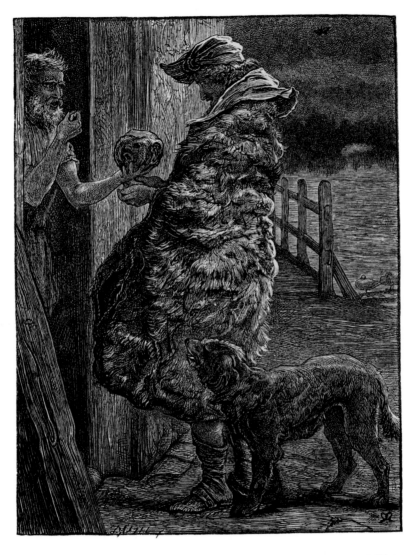

Dalziel Brothers after John Everett Millais,
The Importunate Friend, wood-engraving, 1863

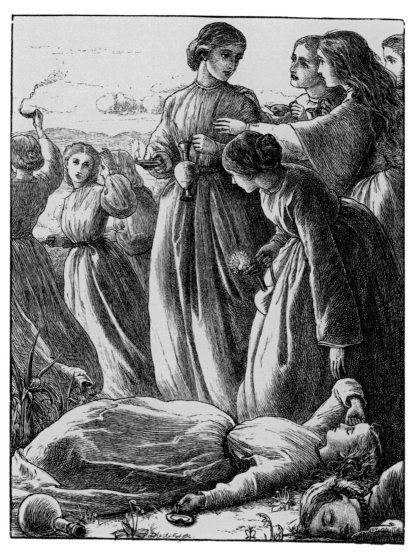

Dalziel Brothers after John Everett Millais,
The Wise and Foolish Virgins, wood-engraving, 1863

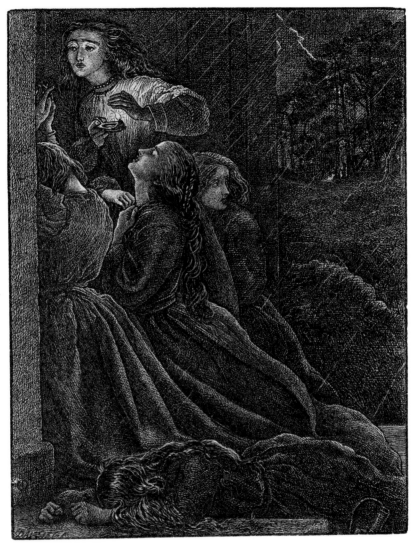

Dalziel Brothers after John Everett Millais,
The Foolish Virgins, wood-engraving, 1863

K EEN TO BE A cultural institution rather than just a money-making enterprise, the Dalziels commissioned drawings from prominent artists to produce ambitious works such as *Parables of Our Lord* (pp. 77–9) and the *Dalziels' Bible Gallery*. The *Bible Gallery* got underway in the 1860s but was not finally published until 1881. The wood-engravings were issued in a luxury portfolio and as a bound volume, and even the latter was a sumptuous vellum-backed folio with red and gilt titles. With the standard issue priced at five guineas, it was doomed to commercial failure. The book included this and eight other pictures by Frederic Leighton, then president of the Royal Academy. There are also numerous illustrations in the Pre-Raphaelite style by artists such as Brown (p. 85), Simeon Solomon (p. 83), Burne-Jones and Hunt.

Leighton's Samson, bent down and straining up with his load, has a force that makes this illustration alive. Leighton was acquainted with members of the Pre-Raphaelite circle such as Rossetti and Burne-Jones, but his own work was quite different, and by the 1860s was largely classical in influence. The use of contrasting artistic styles in a book like *Dalziel's Bible Gallery* was typical of a broad and inclusive attitude to book production at this time. Compare Leighton's pared down depiction of architecture in these walls, done in striking vertical lines, to Brown's more intimate observation of a city wall (p. 85). And Leighton's bare rocky foreground could not be more different from the landscape foregrounds teeming with life that were created by Pre-Raphaelite artists like Sandys (pp. 67 & 93).

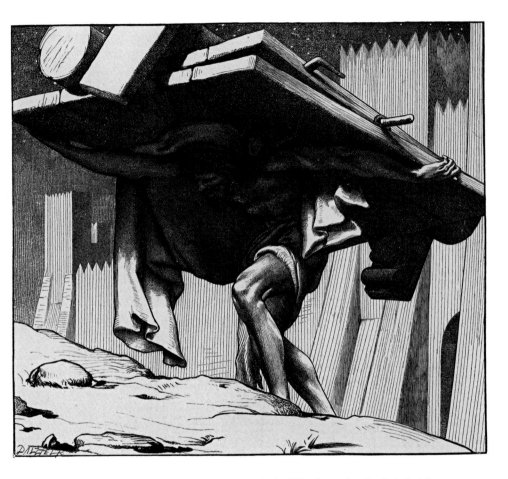

Dalziel Brothers after Frederic Leighton,
Samson Carrying the Gates, wood-engraving,
published 1881

SIMEON SOLOMON contributed six illustrations to *Dalziel's Bible Gallery*. The designs are from the 1860s, when he was a leading young Pre-Raphaelite and a close friend of Rossetti. Later, in 1873, Solomon suffered a humiliating arrest for attempted sodomy in a public toilet. Subsequently, he disappeared from the art world and from the lives of his former friends. In 1881 when *Dalziel's Bible Gallery* was eventually published – a high-profile Christian work – Solomon's name on the contents page must have seemed strange and ghostly.

Art historians have pointed out Solomon's significance not only as a pioneering gay artist but also as one of the first successful British-Jewish artists to capitalize on his identity in his artwork. In 1866 Solomon was to produce a series of illustrations for *The Leisure Hour* depicting Jewish customs. As a painter, he specialized in Old Testament subjects, and given his growing reputation in this field he was an obvious choice when the Dalziel family were commissioning artists for their *Bible Gallery*.

The wood-engraved *Hosannah!* is based on a painting by Solomon. It bears little relation to any specific biblical passage, but was included in the *Bible Gallery* despite this. Like other pictures by Solomon, *Hosannah!* relates to his central role in the Aesthetic Movement. The image is not only about vision, but also addresses other senses. The rapt attention of the young man on his playing suggest the pleasures of hearing, and touch is evoked by the rich textures of his clothing and hair. Other artists involved in the Aesthetic Movement were Rossetti and Burne-Jones. *Cupid finding Psyche* (p. 41) is a picture by Burne-Jones in which sound and smell are suggested by falling water and flowers.

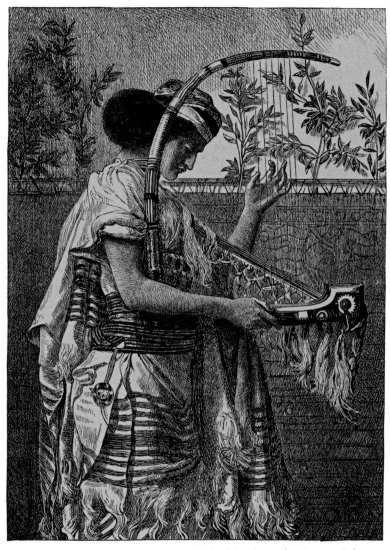

Dalziel Brothers after Simeon Solomon,
Hosannah!, wood-engraving, published 1881

Ford Madox Brown, study for *Elijah and the Widow's Son*,
pencil, *c.* 1863

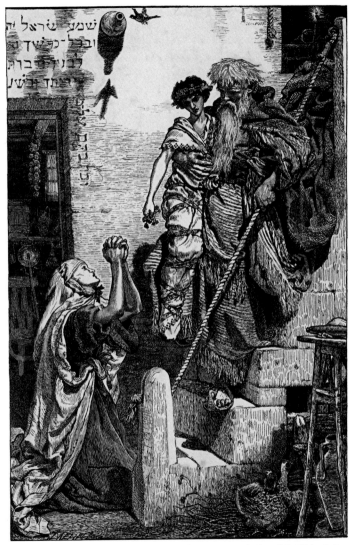

Dalziel Brothers after Ford Madox Brown, *Elijah and the Widow's Son*,
wood-engraving, touched proof, published 1881

FREDERICK SANDYS only completed around thirty wood-engraved illustrations, but they stand out as some of the best of Pre-Raphaelite printmaking. This was partly because of his technique in drawing on wood: he was said to have a clear sense of what was possible for the engraver, drawing everything on the block in black line and avoiding tones and shading that were hard to translate. This wood-engraving, like the one on p. 93, appeared in *English Sacred Poetry*, an illustrated anthology of Christian poetry spanning four centuries.

In *The Little Mourner* Sandys captures the silence of a landscape covered with snow. The girl is looking back over her shoulder: this pose was popular with Pre-Raphaelite artists and can also be seen in Rossetti's *The Maids of Elfen-mere* (p. 47). Here, the spiral of the girl's body and the strong diagonal of her right arm create a powerful idea of motion, captivating the viewer and lending a strength to the girl's activity – she is clearing snow from the graves of her parents and siblings. Sandys's illustration has a melancholy atmosphere that was not quite achieved in the sentimental poem by Henry Alford which inspired it:

"Stranger, underneath that tower,
On the western side,
A happy, happy company
In holy peace abide;
My father, and my mother,
And my sisters four—
Their beds are made in swelling turf,
Fronting the western door."

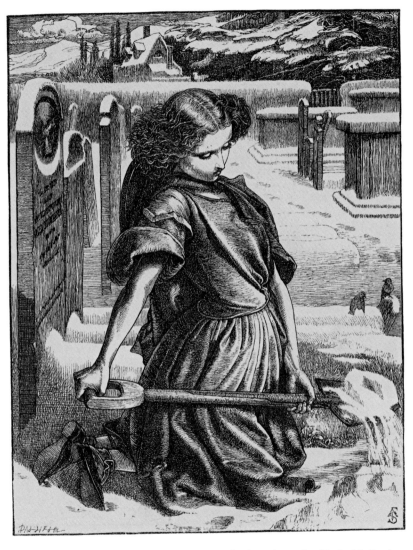

Dalziel Brothers after Frederick Sandys,
The Little Mourner, wood-engraving, 1862

INTERPRETING FICTION

I do not think that I knew at the time that he was engaged on my novel.
When I did know it, it made me very proud. He afterwards illustrated *Orley
Farm*, *The Small House of Allington*, *Rachel Ray*, and *Phineas Finn* . . . I do not think
that more conscientious work was ever done by man. Writers of novels know
well — and so ought readers of novels to have learned — that there are two
modes of illustrating, either of which may be adopted equally by a bad and by
a good artist. To which class Mr Millais belongs I need not say; but, as a good
artist, it was open to him simply to make a pretty picture, or to study the work
of the author from whose writing he was bound to take his subject. I have too
often found that the former alternative has been thought to be the better, as it
certainly is the easier method. An artist will frequently dislike to subordinate his
ideas to those of an author, and will sometimes be too idle to find out what
those ideas are. But this artist was neither proud nor idle. In every figure that he
drew it was his object to promote the views of the writer whose work he had
undertaken to illustrate, and he never spared himself any pains in studying that
work, so as to enable him to do so.

Anthony Trollope, from *An Autobiography*

MILLAIS OFTEN illustrated contemporary fiction, both in books and in
instalments in periodicals. As Trollope suggests, a debate was in
progress — and continues today — about the status of illustrations. Should they
be supporting material for texts, as Trollope and Tennyson maintained? Or
must they stand as related but independent works of art, as proposed by
Rossetti and Hunt? Here, Trollope attempts to discredit the latter belief by his
dismissive description of the 'pretty picture'. However, other writers believed
that illustrations could offer a separate, parallel narrative, as is implied by
best-selling novelist George MacDonald (in the quote overleaf).

Dalziel Brothers after John Everett Millais,
Orley Farm, *'There was sorrow in her heart'*,
wood-engraving, 1862

I give you a book of stories. You have read them all before except the last.
But you have not seen Mr. Hughes's drawings before.

George MacDonald, from *Dealings with the Fairies*

I N T H I S P R E F A C E, addressed to young readers, MacDonald gives a clear
sense of why illustrations were useful to him as a writer: they bring some-
thing extra to the narrative, and help him market a new edition. Arthur Hughes
was a Pre-Raphaelite illustrator and painter, and his designs for children's
books represent some of his best work. He illustrated Thomas Hughes's *Tom
Brown's School Days*, most of MacDonald's children's fiction and children's poetry
by Christina Rossetti.

These wood-engravings are for *At the Back of the North Wind*, which was first
released in instalments in the periodical *Good Words for the Young*, then published
in book form in 1871. The hero is Diamond, a boy fated to die from an
unnamed illness. He meets the North Wind, a magical woman who takes him
on impossible night-time adventures – to city streets, an ocean and cathedral,
the North Pole, and eventually heaven. North Wind, represented in the lower
of these two illustrations, turns out to be a benevolent embodiment of death
itself. MacDonald was a preacher as well as a writer. He himself was to lose
four children to tuberculosis, and child death was still a preoccupation for
Victorian society, which had seen outbreaks of influenza, typhoid and cholera.

Despite being immersed in a compelling fantasy, the reader of *At the
Back of the North Wind* is never allowed to forget social reality. This is typical of a
collaboration between MacDonald and Hughes. And yet, the realities of pain,
poverty and death are sweetened for the child viewer. The upper illustration
shows a street sweeper whom Diamond befriends. But what makes the biggest
impact here is not so much poverty itself as an observed problem, but rather
the aestheticized sentimentality of the girl's portrayal, and the formal beauty of
the print with its dramatic verticals and diagonals.

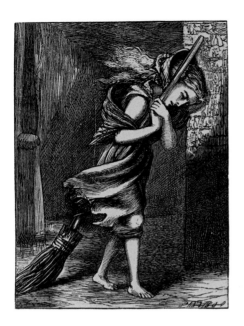

Dalziel Brothers
after Arthur Hughes,
At the Back of the North Wind,
'Won't you help that little girl?',
wood-engraving, 1869

Dalziel Brothers
after Arthur Hughes,
At the Back of the North Wind,
'But why should you cry?',
wood-engraving, 1870

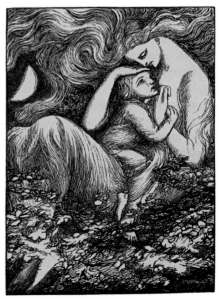

CONCLUSION

PRE-RAPHAELITISM has survived because it was an artistic revolution. Also, because people have kept writing about it. The Pre-Raphaelites were fortunate – or astute – in that many of them were writers as well as visual artists, or had family members willing to immortalize them in print. In terms of retrospective literature, Hunt got the ball rolling in 1886, publishing a series of articles later expanded into a book. Rossetti's younger brother William Michael wrote and edited several books about Rossetti and Pre-Raphaelitism. Millais was written about by his son, and Ford Madox Brown by his grandson, the novelist Ford Madox Ford. Georgiana Burne-Jones published a masterful, appreciative biography of her husband Edward in 1904.

Actually, as early as 1853 a teasing, nostalgic history of the Pre-Raphaelite Brotherhood was written by Christina Rossetti. Excluding James Collinson – it has been suggested this was because their engagement had broken off – she incorporates the stories of the other original members: Thomas Woolner, who had failed financially as a sculptor and gone to try his luck in the Australian gold fields; Hunt, who was about to abandon London for Egypt – she mentions 'Cheops', the king associated with the great pyramid; her brother Dante Gabriel, who was avoiding exhibiting his work; William Michael Rossetti and Frederic Stephens, both non-starters as artists but talented critics; and finally Millais, gently mocked for his election as Associate of the Royal Academy, the epitome of artistic conventionality. The new letters after Millais's name, ARA, could not be further from the radical PRB. Here are two extracts:

> The P. R. B. is in its decadence:
> For Woolner in Australia cooks his chops,
> And Hunt is yearning for the land of Cheops;
> D. G. Rossetti shuns the vulgar optic; . . .

> And he at last the champion great Millais,
> Attaining academic opulence,

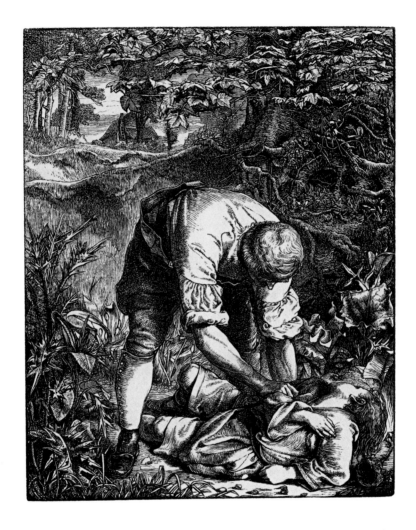

Dalziel Brothers after Frederick Sandys,
Life's Journey, wood-engraving, 1862

Winds up his signature with A. R. A.
So rivers merge in the perpetual sea;
 So luscious fruit must fall when over-ripe,
And so the consummated P. R. B.

The brotherhood ended swiftly, but Pre-Raphaelitism survived tenaciously and
is one of the crucial movements of British art. It escalated beyond itself, effect-
ing profound change in visual culture. The intense, vibrant look was a catalyst
for rigorous new styles in fields of art as diverse as printmaking, interior decor,
painting, drawing and book binding. Whether in uncannily detailed paintings,
experimental drawings, or densely beautiful wood-engravings, Pre-Raphaelite
art continues to offer us an unexpected angle on our world.

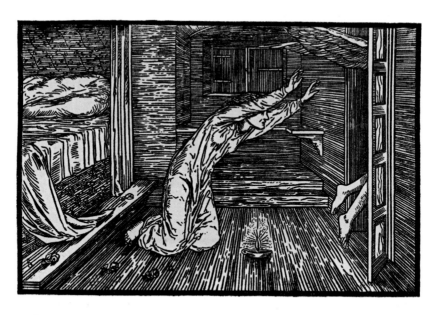

William Morris or Elizabeth Burden after Edward Burne-Jones,
Cupid and Psyche, wood-engraving, proof, *c.* 1865

SELECTED SOURCES & FURTHER READING

Barringer, Tim. *The Pre-Raphaelites: Reading the Image*, London: Weidenfeld and Nicolson (Everyman Art Library), 1998

Bell, Clive. *Since Cézanne*, London: Chatto & Windus, 1922. Reproduced with permission of The Society of Authors as the Literary Representative of the Estate of Clive Bell

Burne-Jones, Georgiana. *Memorials of Edward Burne-Jones*, London: Macmillan, 1904

Cruise, Colin (ed.). *Love Revealed: Simeon Solomon and the Pre-Raphaelites*, London: Merrell, 2005

Dalziel, George and Edward Dalziel. *The Brothers Dalziel: A Record of Fifty Years' Work*, London: Methuen, 1901

Elzea, Betty. *Frederick Sandys, 1829–1904: A Catalogue Raisonné*, Woodbridge: Antique Collectors' Club, 2001

Gere, J. A. *Pre-Raphaelite Drawings in the British Museum*, London: British Museum Press, 1994

The Germ: Thoughts towards Nature in Poetry, Literature, and Art, London: 1850

Goldman, Paul. *Victorian Illustrated Books 1850–1879: The Heyday of Wood-Engraving*, London: British Museum Press, 1994

Goldman, Paul. *Victorian Illustration: The Pre-Raphaelites, the Idyllic School and the High Victorians*, Aldershot: Scolar Press, 1996

Goldman, Paul. *Beyond Decoration: The illustrations of John Everett Millais*, London: British Library, 2005

Hunt, William Holman. *Pre-Raphaelitism and the Pre-Raphaelite Brotherhood*, 2 vols, London and New York: Macmillan, 1905, 2nd edn 1913

Marsh, Jan. *Dante Gabriel Rossetti: Painter and Poet*, London: Weidenfeld & Nicolson, 1999

Millais, John Guille. *The Life and Letters of Sir John Everett Millais*, 2 vols, London: Methuen, 1899

Pointon, Marcia. *Naked Authority: The Body in Western Painting 1830–1908*, Cambridge: Cambridge University Press, 1990

The Pre-Raphaelites, London: Tate Gallery/Penguin Books, 1984

Prettejohn, Elizabeth. *The Art of the Pre-Raphaelites*, London: Tate, 2000

Reid, Forrest. *Illustrators of the Sixties*, London: Faber & Gwyer, 1928, © The Estate of Forrest Reid. Reproduced with permission of Johnson & Alcock Ltd

Rossetti, Dante Gabriel. Letters of Dante Gabriel Rossetti to Jane Morris 1868–1881, British Library Manuscripts Add. MSS 52332–3, quotation from Add. MSS 52332 f. 9v.

Rossetti, Dante Gabriel. *The Works of Dante Gabriel Rossetti*, ed. William Michael Rossetti, London: Ellis, 1911

Rossetti, William Michael (ed.). *Præraphaelite Diaries and Letters*, London: Hurst and Blackett, 1900

Rossetti, William Michael. 'Dante Rossetti and Elizabeth Siddal', *Burlington Magazine*, vol. 1, no. 3, May 1903, pp. 273–95

Ruskin, John. *The Works of John Ruskin*, ed. E. T. Cook and Alexander Wedderburn, Library edn, 39 vols, London: George Allen, 1903–12

Staley, Allen and Christopher Newall. *Pre-Raphaelite Vision: Truth to Nature*, London: Tate, 2004

Surtees, Virginia. *The Paintings and Drawings of Dante Gabriel Rossetti (1828–1882): A Catalogue Raisonné*, 2 vols, Oxford: Clarendon, 1971

Surtees, Virginia (ed.). *The Diary of Ford Madox Brown*, New Haven and London: Yale University Press, 1981, Copyright © 1981 by Yale University

Surtees, Virginia. *Rossetti's Portraits of Elizabeth Siddal: A Catalogue of the Drawings and Watercolours*, Aldershot: Scolar, 1991

Wildman, Stephen and John Christian. *Edward Burne-Jones, Victorian Artist-Dreamer*, New York: Metropolitan Museum of Art, 1998

ILLUSTRATION REFERENCES

Photographs © The Trustees of the British Museum, courtesy of the
Departments of Prints and Drawings and of Photography and Imaging